Gifts of Solitude

Gifts of Solitude

Ashvin Mehta

Introduction by Judith Mara Gutman
Words by Rabindranath Tagore

Mapin Publishing Pvt. Ltd. Ahmedabad

For Tilu,
the guardian of my solitude

Acknowledgements

Mr. Vishwanath of Mitter Bedi, Bombay for producing
very laboriously the press-worthy prints.
Agfa-Gevaert India Ltd. for supplying their
newly introduced Sterling RC paper free of charge.
Ms. Mrinalini Sarabhai, the renowned dancer and
an ex-student of Santiniketan, for compiling the Tagore texts.

First published in the United States of America in 1990 by
Grantha Corporation, 80 Cliffedgeway, Middletown, NJ 07701
in association with
Mapin Publishing Pvt. Ltd.
Chidambaram, Ahmedabad 380 013 India.

Photographs and statement *On Solitude* copyright © 1990 Ashvin Mehta
Introduction copyright © 1990 Judith Mara Gutman

All rights reserved.
No part of this publication may be reproduced,
stored in a retrieval system, or transmitted, in any form or by any means,
electronic, mechanical, photocopying, recording or otherwise,
without the prior permission of the publisher.

ISBN 0-944142-49-4
LC 89-80996

Editorial Consultant: Carmen Kagal
Design: Vala/Mapin Studio

Typeset in Life Roman by Fotocomp Systems, Bombay
Printed and bound by
Toppan Printing Co. (S) Pte. Ltd.

Poems of Rabindranath Tagore printed with permission of the original
publishers.
Pages 12, 22, 28, 38, 44, 68, 94, 116, 122 from *Collected Poems and
Plays of Rabindranath Tagore* copyright © Macmillan Publishers Ltd.,
London, 1937, pages 56, 112, 132 from *Selected Poems:* (Penguin
Modern Classics), copyright © Penguin Books Ltd., London, 1985,
pages 102, 126 and 128 from *Poems* copyright © Visva-Bharati, Calcutta, 1970.

On Solitude

It was a morning after the storm on a remote coral island. Again the sky was transparently blue, and the freshly-washed leaves were aquiver with light. The sun shone in all its tropical fury and probed the humid forest floor in search of tiny purple flowers. The giant umbrella-shaped trees sheltered more birds in their canopies than leaves on their branches. The forest was alive with incessant sounds, both sweet and raucous. A jungle babbler's melodious song rose above the clamour, questioning the noisy celebration of bright and clear day after a week of rains.

The beach on the outskirts of the forest was strewn with huge tree trunks tossed into the sea and washed ashore during the high tide. Some were quite old and worn out, hollowed and polished by many storms of yesteryears. The sea and wind and insects thriving in dark crevices had worked together to carve out grotesque, frightening forms. The vast waters, reflecting the cloudless sky, extended as far as the eye could see, and joined hands with the sky at the seamless horizon. Along the slender shore, glass green water gently lapped the bone-white sand. At times, the plaintive call of a lapwing pierced the warm, sensuous silence. One could almost hear the primordial rhythm of the newborn sea, fresh and buoyant after the millennia of rains. From shore to horizon as the water deepened, it gradually turned from parrot-green to mango-green and jackfruit-green. With a deepening blue, it changed from turquoise to ink-blue to merge into an endless midnight blue, indeed the "Krishna" blue.

I was all alone on the beach looking for pictures, when suddenly it happened. As dimensions of time and space vanished, I slowly dissolved in the fathomless blue. Something confined within the narrow shell of my mind and body was hurled into a whirlpool of ecstasy. When I returned to the reality of the sea, and sand and driftwood logs, it took some time to find my bearings. The invisible bonds of affinity with everything around me made my entry stable and my movements effortless. I don't remember when I finished my photography session and returned home.

एकान्तभक्तिर्गोविन्दे यत्सर्वत्र तदीक्षणम्।

(Solitude is devotion to Lord Krishna, so that one sees him everywhere). A totally new meaning of solitude dawned on me when I came across the above sentence from the *Shrimad Bhāgwat (7.7.55)*. Solitude is not isolation, shutting up oneself from the outside world of contemplation or work, or out of malaise and depression. It is a state of mystic communion with the source of all energy and all its material manifestations. The photographs in this book are the gifts of such solitude, mostly created in the scintillating moments of my entering the world of rocks and trees and water. The collection of colour photographs will appear in my forthcoming book *The Primeval Landscape*.

Ashvin Mehta

Introduction

It's possible to back away from these photographs. Neither predictable nor expectable they do not slip into such ready-made categories of nature as landscapes or seascapes, even though they are of the land, the sea, and the mountains and rocks washed by sea. With similar elusiveness, they are neither contented and lyrical nor violently powerful, evading easy classification of their emotional impact. All of this makes them strangely unsettling, so much so that it's often hard to say whether, in looking at the photograph, you are one inch or ten feet away from a subject, hanging in mid-air or off on the next rise. It's hard to get your bearings. Still, most viewers do not turn away but are rather drawn into the photographs, ready to absorb the photographs' particular grab.

Ashvin Mehta, who was born nearly 60 years ago, made many of his photographs in the countryside around Bombay. He achieves a rare state of communion with nature, transcending the bounds of time and space. His photographs are, in his own words, a celebration of the gods. And the most gripping fact about them is that for all they do and evoke, they *are* photographs, and they are not painting, sculpture or any other form of art. Their fusion of Hindu otherworldliness and photographic worldliness begins to explain their grip on our sensibilities.

It is not that they depend on Hindu associations or on nature for understanding, even though they are of nature and have grown out of basic Hindu understandings. It is rather that, in spite of their singular attachment to Hinduism, nature, and a photographic presence, they have another life, one that has nothing to do with their particular origins, but with the development of abstraction and conceptualization in contemporary art, and with present-day issues of urbanization, selfhood, and the new understandings of the sciences of complexity — the random non-linear nature of life that may lie beneath all that we have ordered. Not that these photographs draw directly on abstract or conceptual art, or the newer post-conceptual thinking — any more than they directly draw on nature photography or photojournalism. A part of contemporary society's unnerving reach for a way out of chaos and unrest, they sit inside a rumbling, wanting 20th century world that overruns as it uses nature, that looks for scientific identification of the unknown, and that, on one scale, gains increasing insight from photography and, on another scale, runs off with its power rather than its insights. As much as these photographs grow out of particular origins, they reach into all contemporary society as, in their search for persuasive universals, they suggest an order that underlies the seeming chaos.

Mehta anchors his search in nature, but once settled into its environments he is unlike others photographing nature. He starts from its interior, as if he had located himself somewhere in the random unpredictable flow of unrecognizable elements. He goes there because it is where his mind and spirit converge, where he can best see beyond himself and beyond the routines of his daily life, especially from those he served in Bombay where until 1973 he worked as an

advertising executive for a pharmaceutical company. Bombay was not yet the city of stifling congestion and stark highrises it has since become. Nor of shacks made by the homeless working poor. But it was becoming and already turning into the clipped, clamorous, and very glamorous city of the rich and well-born, a centre for urban fantasy in film-making, a city of ten million people. It was becoming a city that shook up traditional issues of Indian social organization.

Mehta made frequent trips outside Bombay. He first went to the Himalayas in 1954 when he was 23, a young man on a trek. He enjoyed the wilderness, in part because he experienced the continuity so fundamental to Indian thought — that man and nature are extensions of each other, no line separating one from the other, no distinction, as the psychoanalyst Sudhir Kakar puts it, "between subject and object". Mehta took his aunt's 1930 Kodak camera with him on that first trip to the Himalayas, the folding model so technologically "advanced" that it included an F64 stop, and found himself taking pretty pictures, as an ordinary tourist, of an overwhelming place.

None of those pictures are in this book. The earliest photographs here date from 1965 and go up to 1982. And though Mehta now lives in a small village near Bombay where he finds relief from the pounding, problems, and profusion of urban activity, most of the photographs were taken when he did live in an urban setting, and most represent his increasingly sophisticated awareness of who he was and how he came to be making them.

But the Himalayan majesty drew him back repeatedly over some 20 years. He also made frequent week-end treks to nearby hills and mountains, always with a camera, first a Rollieflex, then a 35 mm. In the beginning, he followed the adventurous amateur's inclination to make the familiar unfamiliar. But in this same period, constructing the advertiser's art day by day, he knew how forceful an image could be, particularly a graphic image; and he knew the artifice necessary for creating an image. To equip himself better aesthetically, he sought out India's sculptors, painters, and photographers, particularly Shri R.R. Bhardwaj, a nature photographer much loved and so emulated that he was familiarly called "guruji". Mehta learned photographic essentials from him, and was influenced by the work of Raza, Gaitonde, Laxman Shrestha and other contemporary Indian artists, whose abstractions evoke associations far beyond the purely visual. Absorbing photographic and aesthetic essentials, Mehta also reinforced the basics of Indian life and learning.

In the city, Mehta began abstracting forms from the tangible reality he saw around him. He photographed ship funnels, tonga-wheels, petrol pumps — mostly from the streets of Bombay; and then he went off to Idar, a village north of Ahmedabad, to that rocky scape, some of these photographs having the look of a Henry Moore sculpture (page 92). Mehta had begun to touch nature — not yet move inside its interiors.

Like others on the subcontinent pushed too hastily into an urban world, Mehta searched for a new reality that would accommodate the temporal disorder he saw around him with the highly ordered world of Hindu culture. So he turned to other natural settings — not only to the Himalayas but to the idyllic sands outside of Bombay, the rocky shores around Porbandar and Hyderabad's sparse, statuesque forms, its miles of rock rounded by eons of sun, wind and water. Looking for a new reality, he was as yet unaware that he would find it not in nature but in a Nature that so "dazzled" his eyes that he could only aptly think of it with a capital "N". He was also not yet aware he would find not *it* but a new Reality he would similarly look at as an all-engrossing, overwhelming force. His link of Nature and reality was especially reinforced by his repeated trips to the mysterious and dazzling Himalayas.

Mehta's grandfather lived in Surat, an ancient trading town north of Bombay, and his frequent visits there increased his understanding of the deeply etched circles of Indian life — his family,

the village of his birth, its different castes — all those circles that reinvigorate as they prescribe the social organization that encompasses life on earth for an Indian. Unlike a Western organization of life which follows a linear pattern, layers of circles — like those of an onion, as the anthropologist Bernard Cohn describes it — structure Hindu society, the father, the grandfather, the village, and a person's caste each occupying a circle, a person in the centre radiating his attachments to all. Submerging his self in others, he and they became one. In a Hindu understanding of life, the self is *in* the other, *in* the family, *in* nature. Mehta visited Surat for summer holidays and saw that continuity run out from himself to the "other" where the other was not only his family but nature. These attachments "guaranteed the sense of sameness with the other as it affirmed the inner continuity of the self," as Sudhir Kakar put it. Slowly, Mehta began to see a new reality emerging jointly from nature and from the structure of Hindu society (page 19).

When he saw people standing with folded hands awaiting sunrise at Puri in Orissa, celebrating Lord Krishna's day of birth on the western shore at Dwarka, and others immersing Ganesh in Bombay's sea, he realised that "the sea itself became, for the devotee, the vast body of the deity, [and how] bathing in the sea was a way of touching and communicating with it". His own turn to nature involved a similar attachment.

"Through Nature," Mehta says, "I become That" — "That," as he translates the Sanskrit, "a visible symbol of the Invisible... a part of the great order which manifests itself in revolutions of stars and galaxies, in tides of oceans, in cycles of seasons, and those of growth and decay." As if he had not already trod on elusive ground by using the most technologically representative form of art to personify the invisible, he further explains that through his photographs he tries to portray the five basic elements of Hindu thought — fire, earth, space, water and wind — not as elements but as the Gods who form the limbs of the Formless. They appear as pure manifestations bearing no earth-born reality, no literalness whatsoever — no form, colour, or age. Standing next to a rock, touched by the waters, he becomes at one with the rocks, seas, land, trees, grass, letting the outer and material shapes of nature fall away to reveal an innermost Source and Provider (page 70).

In many senses, he echoes truths that religions over the centuries have uttered. Nature, as a phenomenon in Hindu thought, wears the clothes of the Immortal on earth, becomes the God of gods, the Universal that gives as it takes, presides as it withdraws, and that provides as it rejects. It assumes the role of Keeper, of Guardian, and represents the Ultimate on earth. The American thinker Ralph Waldo Emerson saw that "standing on bare ground, my head... uplifted into infinite space... the currents of the Universal Being circulate through me; I am part or particle of God." In Hindu — as in Jewish, Egyptian, Chinese — tradition trees become sacred objects through which God makes His Presence felt, the Vedic period of Hindu culture further portraying nature as the "home of divine spirits", as the Indologist Herbert Stroup put it, but that it provides a coherence and uniformity to "be detected in all natural phenomena."

But it is the ability to provide fire *and* water, earth *and* sky — opposites that work against each other in mortal life — that gives belief in that Keeper its fundamental strength, Nature its elusive power. That power to reinvigorate contradictory moves — to cripple and elevate — keeps belief in Its existence alive. Mehta experiences that. He feels the disorders, but also feels a "certain order amidst the disorder." Belief in the power to create opposites in India, Europe, Africa, or the Americas has intensified the search for clearer representation of that power. What gives Mehta's immersion in Nature such contemporary force is his use of photography to do so. It is both like and unlike other movements in photography around the world, and not unlike other movements to probe beyond the rational order.

It is unusual to have photography so tied into religion, and tied into a nature so loaded with the Universal. More than any other single form of expression or any other form of art, photography

has used the language of reality and has gained credibility and power through reality. This is not Mehta's "reality" emerging from a religious understanding of life, but the reality of cars, faces, streets, dirt, even of sea and sky — reality one can meet up with in a city or in a forest. Unlike objects which, in Indian thought, are wedded to a subject, these are objects one confronts, distinct from the subject. From the beginnings of photography on, when Fox Talbot photographed a sun-drenched broom outside a door, when Alfred Stieglitz photographed people in "Steerage" and the steam and streets of New York, and when Ansel Adams captured the majesty of forest, mountain and moon, the real object has always affixed itself to the camera. Photography's attachment to reality, which has been almost automatic, runs against the grain of an Indian Reality.

"Automatic" because the photograph, in what can be understood only as a generic attachment to reality, has developed a credibility that no other art form possesses. Looking at a photograph, accepting its frame is akin to looking into the reality which it has basically lifted from the real world. Much of the viewer's insistent turn to the photograph in the 20th century comes from the photograph's undeniable cut into that reality, from its abstraction of a reality we know, can identify, and can conceivably touch. So much so that a photograph actually invites a viewer to see it as a separate subject and ask it questions: where and what or who it is. That is very different from looking at a painting or sculpture when we may wonder what a painting is but not be thrown askew and made uneasy but not locating the reality from which the painting sprang. And it is very different from an Indian reality that blends who and what, subject and object into one complex whole. To enjoy and take from a photograph, we have always felt the need to identify its parts — image it. Not imagine it, but turn it into an image of something out there, clear in itself distinct from us.

Contemporary photography, however, has complicated the photograph. It has added a conceptual reach which, though superficially at odds with reality, has not abandoned the photograph's pragmatic face but has actually reinforced it. In the last decades, the photograph has taken on, along with its language of direct representation, the language of thought and feelings. Some of this has come about because of photography's new-found place as a saleable art, as an art hung in galleries and museums and supported by universities training curators, buyers, sellers, critics and collectors. Photography moved into this structure of sales as art itself was moving from abstraction to conceptualization and on to what I can only call a heightened conceptualized reality, or post-conceptualization. As a result, photographers, painters, and sculptors have all started talking to each other, not with words so much, although that, too, has happened, but through the symbols of artistic expression. They've developed artistic dialogues, painters and sculptors taking on the artistic (and economic) value of photographic reality while photographic artists have absorbed the techniques, materials and language of painters' and sculptors' processes of abstraction and conceptualization.

But some of photography's new search has come from a totally different movement, from a movement that runs mainly but not exclusively through the Western world — a search for history, for an expression to encompass the thick and complex texture of 150 years of photographic development. The search has been not so much for linear elements that add to the volume of facts, but for a *weltenschauung*, a kind of spiritual base that could account for photography's reach over time, for a way of trying to figure out why and how the development took place as it did, and for a way to locate the random, non-rational with the rational elements that have figured in its development.

Different modes of photographic expression have evolved from that search. In the hands of Aaron Siskind and his rocks, photographic expression has leaned toward abstraction; in the hands of Cindy Sherman it has become conceptual. But in the last decades, photography has gone clear back to its origins. Many young photographers have been using primitive processes

and techniques of 150 years ago, often with the hopes of locating where the random and the rational coincided, and of finding a new route into the present. The net result is greater than the sum of its parts. Out of this has developed a new language, one that combines photography's new and past modes of expression, and with it a much overlooked character, photography's continual sense of adventure with its probing, integral tie to exploration. This new search has actually created something close to a lien on exploration, established such a preemptive hold on it that photography has deepened its traditional hold on that power to explore while striking out in new directions.

Ashvin Mehta's photographs are part of this reach, which is not quite a movement because there is no co-ordination, but rather a series of unconnected attempts happening simultaneously around the world. Mehta might be impelled by such general forces as the move to redefine the self in contemporary society, a move that is especially made vivid by the many realities of urbanization. As a man of the subcontinent, however, he brings a special approach to that exploration. He is not worried about losing his self: he sees it fused to the Invisible. Neither is he worried about other chaotic turns. He sees "a certain order amidst disorder, a certain centre of stillness amid the vortex of discordant voices." What he does not say is that his order is of a different sort. It is made of non-linear relationships that are not readily apparent.

A Mehta photograph refuses to let the viewer stand in what we call the real world with two feet squarely implanted on earth. When you look at the picture on page 80, for example, it is difficult to say whether you are inside a cave looking out from the cave or on top of a mountain range with shafts of light streaming in. In the picture on page 119 is the viewer looking at a night sky with fireworks, or looking at a dark pool with sea grass — standing on identifiable ground or at the water's edge? Does the picture on page 129 depict sand or water, the viewer standing inches or feet away? A Mehta photograph denies older understandings of photographic reality and forces the viewer to see a photograph only from a conceptualized vantage point. What may seem askew and off-base becomes the key to reading Mehta's photographs.

In large measure Mehta positions himself inside a phenomenon. "Real" shapes, as for example on page 51, are unrecognizable, the black and white of the photograph not cueing viewers into the photograph's top or bottom, the microcosmic at one with the macrocosmic. Looking at the photograph seems akin to opening a book and reading from the inner seam out to the right and left sides simultaneously and with equal weight. The picture on page 51 seems to be an arrangement of sea on sand with a light-emblazoned pool of water. It is not clear whether it is a darkened sea lit by the moon or some unidentifiable "other". But in trying to find out, viewers are drawn into feeling the oozing moves of the water.

These photographs spill emotion. Not in a uniform single flow. But just as the self spills into the family in Indian society, and a subject fills up with its objects, emotion becomes part of a thick moving texture. "Emotion is not an isolated human phenomenon", the Sanskritist Barbara S. Miller points out. It is a complex weaving of elements. When Mehta talks of celebrating the gods by photographing "the ethereal sunshine after a snowstorm in the Himalayas, a single tender tree standing resolutely against the shadows of an entire forest," he opens us to the sensuous-to-sexual nuances in Indian life, showing that "the natural world... in its seasonal transformations expresses the emotions of man" (Barbara Miller). Sometimes he extends that sensuality into sexuality, as in the picture on page 1. At other times he accompanies his photographs with the verbal language of sexuality, talking of sea-breakers "enticing stolid rocks."

Yet these photographs can just as satisfactorily be read as a conceptualized arrangement of light, devoid of their Indian connection. Take Mehta's photographs outside their particular origins, strip them of their particular associations, and they can be seen as non-rational but exquisite combinations of order and intensity. All the more unsettling and extraordinary.

Mehta, it might be said, unknowingly combines the exquisiteness of rational order with the intensity of feeling which others, in other parts of the world with different philosophic roots, are searching for.

Mehta is really *re*-arranging earthly relationships, throwing objects normally seen in a tangibly real linear relation to each other into a Real relationship. The black rock (page 37) at the top hangs strangely above the liquid movement of the sea and in a still stranger place in the frame — until one takes up a vantage point somewhere inside that flow, inside that mass of space to look at the material world from inside the life going on with the gods. Then the objects we first call out of scale hang in an acceptable, understandable balance, are part of that continuum that roots them in their very particular origins.

What catapults them out of their particular origins, however, is the character of the movement they develop. Somewhere between an Indian understanding of the inanimate as animate and a Western artist's ordering across a canvas, they become denominators for a universal desire to bring order out of chaos. Giving shapes in a photograph a texture with flesh-like attributes, as Mehta does on page 35 and page 50, makes the shapes look as if they will somehow edge themselves forward. Even rocks (page 55) begin to take on this compositional almost animate component, as if they are about to march off into a universal future.

Mehta's photographs personify something beyond and grander than themselves. They share, with scientists and creative thinkers everywhere, a search for some supreme, if not yet identified, order. Going beyond the recognizable rational order so identified with abstraction and conceptualization in the arts and the rational use of the scientific mind to produce microcosmic understandings of the universe through science, they suggest a non-rational existence. Scientists are calling such non-rational understandings "chaos" for its random, as yet undefinable organization, and see it as lying somewhere beyond the meticulous probes that have, among other feats, sent a satellite to the outer reaches of the Universe. These new scientific probes recognize that, in the same way the poet William Butler Yeats saw that "things fall apart; the centre will not hold," there exists an as yet unfathomable complexity. It is this random nature of life beyond the linear ordering of life that has shaped Western thinking since Newton that they try to identify. And just as scientists look for an opening into these new complexities by using the roads opened by their highly rational, microcosmic probes into the unknown, artists use insights gained through conceptualization and abstraction to probe relationships they see beyond those of the real world.

These photographs are part of this driving search to locate and represent the unknown. A Mehta photograph seems to get up and off the page, move in ways we cannot see from our real tangible stance. That Mehta arrived at this state through a religious and cultural non-linear framework is challenging and provocative — to scientists and all creative thinkers. And, as these new sciences of complexity have grown, an association with Indian cosmology has emerged. That he arrived at this state through photography, however, using the art of the tangible to identify the invisible is unnerving. And enlightening. Mehta's photographs not only represent, but breathe life into the unknown. In doing so, they reinvigorate photography's legacy, its uncanny power to explore and move beyond with its feet, so to speak, firmly implanted in this world.

<div style="text-align: right;">Judith Mara Gutman</div>

There are tracts in my life that are bare and silent.
They are the open spaces where my busy days had their light and air.

Let my doing nothing when I have nothing to do
become untroubled in its depth of peace like the
evening in the seashore when the water is silent.

"I cannot keep your waves," says the bank to the river.
 "Let me keep your footprints in my heart."

Like the meeting of the seagulls and the waves we meet and come near. The seagulls fly off, the waves roll away and we depart.

"What language is thine, O sea?"
"The language of eternal question."
"What language is thy answer, O sky?"
"The language of eternal silence."

Earth, clamped into rock or flitting into the clouds;
 Rapt in meditation in the silence of a ring of mountains
Or noisy with the roar of sleepless sea-waves;
 You are beauty and abundance, terror and famine.

I have scaled the peak and found no shelter in fame's bleak and barren height. Lead me, my Guide, before the light fades, into the valley of quiet where life's harvest mellows into golden wisdom.

Be still, my heart, these great trees are prayers.

Waves rise and fall,
the flowers blossom and fade
and my heart yearns for its place
at the feet of the Endless.

O profound,
Silent tree, by restraining valour
With patience, you revealed creative
Power in its peaceful form. Thus we come
To your shade to learn the art of peace,
To hear the word of silence; weighed down
With anxiety, we come to rest
In your tranquil blue-green shade, to take
Into our souls life rich, life ever
Juvenescent, life true to earth, life
Omni-victorious.

My evening came among the alien trees and spoke in a language which my morning stars did not know.

The grass seeks her crowd in the earth.
The tree seeks his solitude of the sky.

On the fairy web in the forest path
the light and shadow feel each other.
The tall grass sends waves of laughter to
 the sky in its flowers,
and I gaze upon the horizon, seeking
 for my song.

I feel the tenderness of the grass in my
 forest walk,
the wayside flowers startle me:
that the gifts of the infinite are strewn
 in the dust
wakens my song in wonder.

I shall meet silence with silence under
 this sky.
I shall become one with the night,
 clasping the earth to my breast.
Make my life glad with nothing.
The rains sweep the sky from end to end.
In the wild wet wind jasmines revel in
 their own perfume.
The cloud-hidden stars thrill in secret.
Let me fill my heart to the full with
 nothing but my own depth of joy.

List of Plates

Page

1	Murud, Maharashtra	1972
13	Murud, Maharashtra	1972
14-15	Tithal, Gujarat	1981
16	Uttan, Maharashtra	1969
17	Porbundar, Gujarat	1969
18	Porbundar, Gujarat	1969
19	Juhu, Bombay	1965
20-21	Kihim, Maharashtra	1970
23	Mahabalipuram, Tamilnadu	1970
24-25	Porbundar, Gujarat	1976
26	Tithal, Gujarat	1982
27	Uttan, Maharashtra	1967
29	Kihim, Maharashtra	1967
30-31	Uttan, Maharashtra	1969
32	Kihim, Maharashtra	1968
33	Kihim, Maharashtra	1968
34	Kihim, Maharashtra	1967
35	Ubharat, Gujarat	1967
36	Murud, Maharashtra	1972
37	Kihim, Maharashtra	1965
39	Uttan, Maharashtra	1969
40-41	Murud, Maharashtra	1973
42	Porbundar, Gujarat	1969
43	Ubharat, Gujarat	1969
45	Mahabalipuram, Tamilnadu	1970
46-47	Porbundar, Gujarat	1969
48	Ubharat, Gujarat	1967
49	Porbundar, Gujarat	1976
50	Porbundar, Gujarat	1976
51	Mahabalipuram, Tamilnadu	1970
52-53	Porbundar, Gujarat	1976
54	Porbundar, Gujarat	1976
55	Uttan, Maharashtra	1973
57	Hampi, Karnataka	1979
58	Idar, Gujarat	1976
59	Idar, Gujarat	1976
60-61	Hyderabad, Andhra Pradesh	1978
62	Idar, Gujarat	1976
63	Idar, Gujarat	1976
64	Jhanjmer, Gujarat	1978
65	Uttan, Maharashtra	1979
66	Hyderabad, Andhra Pradesh	1980
67	Idar, Gujarat	1976
69	Idar, Gujarat	1976
70	Idar, Gujarat	1976
71	Idar, Gujarat	1976
72-73	Bhedaghat, Madhya Pradesh	1976
74	Idar, Gujarat	1976
75	Uttan, Maharashtra	1976
76	Uttan, Maharashtra	1965
77	Bhedaghat, Madhya Pradesh	1976
78	Idar, Gujarat	1976
79	Idar, Gujarat	1976
80	Harihareshwar, Maharashtra	1972
81	Taranga, Gujarat	1974
82-83	Idar, Gujarat	1976
84	Idar, Gujarat	1976
85	Idar, Gujarat	1976
86	Idar, Gujarat	1976
87	Idar, Gujarat	1976
88-89	Idar, Gujarat	1976
90	Uttan, Maharashtra	1979
91	Idar, Gujarat	1976
92	Idar, Gujarat	1976
93	Idar, Gujarat	1976
95	Igatpuri, Maharashtra	1968
96-97	Hampi, Karnataka	1979
98	Khalsi, Ladakh	1980
99	Srinagar, Kashmir	1978
100	Banihal, Kashmir	1978
101	Nargol, Gujarat	1970
103	Aksha, Maharashtra	1976
104-105	Garhwal, Uttar Pradesh	1977
106	Uttan, Maharashtra	1976
107	Mandu, Madhya Pradesh	1969
108	Uruli, Maharashtra	1969
109	Gangabal, Kashmir	1978
110-111	Srinagar, Kashmir	1979
113	Modhera, Gujarat	1974
114	Srinagar, Kashmir	1977
115	Jaisalmer, Rajasthan	1973
117	Sandakphu, Darjeeling	1979
118	Maldives	1987
119	Salher, Maharashtra	1972
120-121	Garhwal, Uttar Pradesh	1977
123	Modhera, Gujarat	1966
124	Atul, Gujarat	1972
125	Uruli, Maharashtra	1970
127	Uruli, Maharashtra	1969
129	Kihim, Maharashtra	1971
130-131	Mandu, Madhya Pradesh	1969
133	Shrivardhan, Maharashtra	1970
134	Uruli, Maharashtra	1965